YOU ARE 24 CARROT GOLD

First published in Great Britain in 2019 by Pyramid, an imprint of Octopus Publishing Group Ltd, London.

You Are 24 Carrot Gold. Copyright ©2019 Octopus Publishing Groups Ltd.

All rights reserved. No part of this book may be used or reproduced in any manner whatsoever without written permission except in the case of brief quotations embodied in critical articles and reviews. For information address Harper Design, 195 Broadway, New York, New York 10007.

HarperCollins books may be purchased for educational, business, or sales promotional use. For information please email the Special Markets Department at SPsales@harpercollins.com.

Published in 2020 by Harper Design An Imprint of HarperCollinsPublishers 195 Broadway New York, NY 10007 Tel: (212) 207-7000 Fax: (855) 746-6023

harperdesign@harpercollins.com www.hc.com

Distributed throughout North America by HarperCollins Publishers 195 Broadway New York, NY 10007

ISBN 978-0-06-298537-8

Printed in China First Printing, 2020

Publisher: Lucy Pessell Designer: Lisa Layton Editor: Sarah Vaughan

Assistant Production Manager: Lucy Carter

YOU ARE 24 CARROT GOLD

words of love for someone who's worth their weight in root vegetables

Τ():	
FROM:	

ALOE ALOE

I YAM HERE FOR YOU
TODAY AND I WILL
BE HERE FOR YOU
TOMARROW

YOU'RE THE BEST FIGGIN' FRIEND I HAVE

I WALNUT LEAVE YOU BEHIND ENEMY LIMES

ME AND YOU.

I'M HAPPY

WITH THIS

ORANGEMENT.

YOU HERB IT HERE FIRST, YOU ARE MINT

THERE'S NOTHING I'D GUAVA BE
THAN YOUR FRIEND

YOU'RE COOL BEANS

I'M HAPPIEST WHEN I'M RIGHT NEXT TO YUZU

I THINK YOU ARE MARJORAMAZING

YOU ARE MY LIFE LIME

YOU FLOAT MY OAT

YOU ARE THE MISSING PEAS OF MY HEART

I WANT TO KNOW YOU LENTIL THE END OF THYME

"IF YOU LIVE TO BE A HUNDRED, I WANT TO LIVE TO BE A HUNDRED MINUS ONE DAY, SO I NEVER HAVE TO LIVE WITHOUT YUZU"

LETTUCE CELERYBRATE THE GOOD TIMES

YOU PUT A SPRING ONION IN MY STEP

THERE'S SO MUSHROOM IN MY LIFE FOR YOU

I LOVE YOU FROM MY HEAD TOMATOES

YOU ARE THE ONION FOR ME

SO MUCH

I CAN'T REZEST YOU

YOU'RE MY DEFINITION OF PEARFECT

WE MAKE A PEARFECT TEAM

I AM SUPER GRAPEFUL FOR ALL YOU'VE DONE FOR ME

YOU ARE THE PEA'S KNEES

YOUR SMILE IS LIKE THE SUNRICE

YOUR GRAPENESS KNOWS NO BOUNDS

WE WERE MINT TO BE FRIENDS

YOU'RE JUST TOO GOURD TO BEETROOT

1

I WILL BE YOUR FRIEND LENTIL THE END OF THYME

"ENDIVE THE WORLD ENDS
TOMORROW, I WILL FACE
IT WITHOUT SORROW, FOR
MY GREATEST DREAM HAS
COME TRUE, IN THIS LIFE,
I WAS LOVED BY YUZU"

YOU HAVE ALL MY R.E.S.PEA.E.C.T.

YOU'RE MY RAISIN FOR LIVING

LET'S MAKE A DILL: WE'LL BE FRIENDS FOREVER

YOU ARE THE MISSING PEAS OF MY SOUL

I WANT TO BE JALAPEÑO HEART

YOU CHIA ME UP WHEN I'M DOWNBEET

...

YOU'RE GOURDGEOUS

I NEED YOU LIKE A HEART NEEDS A BEET

RICE AND SHINE!

YOU ARE RADISHING

DID I MINTION I THINK YOU'RE GREAT!

TRUE FRIENDSHIP NEVER DIES,

IT ONLY GETS STRONGER WITH THYME

I'M BANANAS ABOUT YOU

YOU HAVE REPLACED MY
NIGHTMARES WITH BEANS, MY
WORRIES WITH HAPPEANESS,
AND MY FEARS WITH LOVE

"LETTUCE HAVE PEAS"

ULYSSES S. GRANT

YOU'RE NOT MY NUMBER 1

YOU'RE MY ONION

"YOU MAY SAY I'M A DREAMER... BUT I'M NOT THE ONION"

I'M SOY INTO YOU

"THERE IS A LIGHT THAT NEVER GOES SPROUT"

DON'T WORRY, BE A PEA

"THERE IS
ONION HAPPINESS
IN THIS LIFE.
TO LOVE
AND BE LOVED."

PEAS DON'T FIGET I LOVE YOU

THANK YUZU FOR BEING THE REASON I SMILE

YOU MAKE MISO VERY HAPPY

YOU'RE THE YIN TO MY YAM

HATERS GONNA HATE, WE DON'T CARROT ALL

ENDIVE I KNOW WHAT FRIENDSHIP IS, IT'S BECAUSE OF YOU

"ACASHEW SHEW SHEW, PUSH PINEAPPLE SHAKE THE TREE"

YOU'RE ALL I AVO DREAMED OF

YOU ARE MY SOY MATE

I WILL ALWAYS CLOVE YOU

YOU SALSIFY MY SOUL

YOU ARE TOATALLY AMAIZEING

#toatsamaizeballs

I WILL BE HERE FOR YOU COME GRAIN OR SHINE

ALOE HA! HIGH CHIVE!

YOU'RE FIGGIN' AMAZING

I MUSTARD MIT I THINK YOU'RE GREAT

YOU ARE SALAD GOLD

THERE SHALLOT OF ROOM IN MY LIFE FOR YOU

YOU KNOW YOUR ONIONS

"LETTUCE GROW TOGETHER, ENJOY TOGETHER"

"LIVIN' ON A PEAR"

YOU RAISIN THE ROOF

YOU'RE MY NO GRAINER

(IHIS IS GEITING DAT OF HAND)

ONCE YOU STOP CHASING THE WRONG THINGS, THE RIGHT ONES CASHEW

A SONG I'D SING TO YOU:

"I BAYLEAF
IN MIRACLES,
SINCE YUZU
CAME ALONG"

HOT CHOCOLATE

I AM YOUR CHIA LEADER

"I SAY A LITTLE PEAR FOR YOU"

NIGHT, NIGHT, SWEDE DREAMS

THAT SHALLOT!

For those of you who haven't herb enough, and haven't herb-it-all-bivore, this series has all the chiaing things you've ever wanted to say in vegan-friendly puns*.

Find the pearfect gift for any occasion:

AVOCUDDLE

comfort words for when you're feeling downbeet

YOU ARE 24 CARROT GOLD

words of love for someone who's worth their weight in root vegetables

*Or plant-based puns if, like us, you are no longer sure if avocados are vegan. Or friendly.

AVOCUDDLE

comfort words for when you're feeling downbeet

YOU ARE 24 CARROT GOLD

words of love for someone who's worth their weight in root vegetables

ACKNOWLEDGMENTS AND APOLOGIES

WITH THANKS TO ANDREW, ANNA, STEPH AND MATT FOR THEIR CONTRIBUTIONS, AND SPECIAL THANKS TO JOE AS HIS CONTRIBUTIONS WERE REALLY QUITE GOOD.

WE REGRET NOT BEING ABLE TO SAY ANYTHING NICE WITH CAVOLO NERO, KOHLRABI, SORREL AND FENUGREEK.
WE HOLD ANYONE WHO CAN IN THE HIGHEST REGARD.

"PATIENCE IS BITTER BUT ITS FRUIT IS SWEET"

ARISTOTLE